Zandeer, the Beautiful Spirit of Children came with a dream.
A very special magical dream.

THE SNOWMITES

This is the story of how Zandeer, the Beautiful Spirit of Children
transformed an iceberg into an enchanting Island of Ice
and then created the lovable Snowmites.
Aqua, Turquo, Fluo, Gyp, Topaz, Jasper and Jadea.
And the Snowmites are here to share with you,
endless nights of magic dreams.

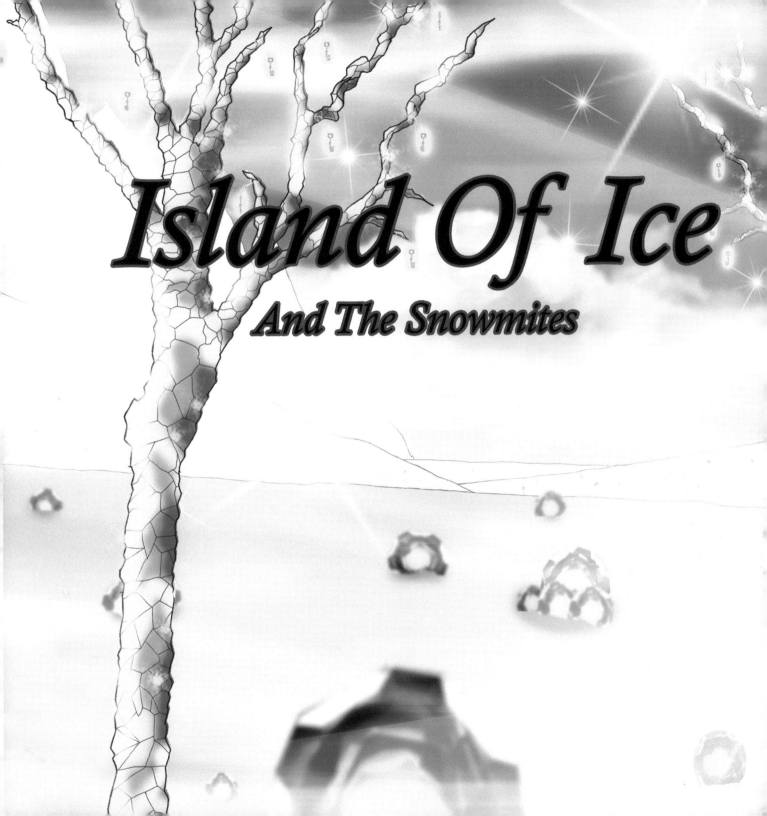

AuthorHouse™ UK Ltd.
500 Avebury Boulevard
Central Milton Keynes, MK9 2BE
www.authorhouse.co.uk
Phone: 08001974150

First published by AuthorHouse 3/13/2009

ISBN: 978-1-4389-1296-7 (sc)

Printed in the United States of America
Bloomington, Indiana

This book is printed on acid-free paper.

authorHOUSE®

Dedicated to

Samantha who believed in the Magic Dust
Oliver who believed in the Elves
Westley who believed in the Love

Also for my dearest friend Roger

And special personal thanks for
Dr. R.N. Curzon. (G.P)

From
Gilmory James

And to
All my family and friends who believed in me

From
Ken Dawson

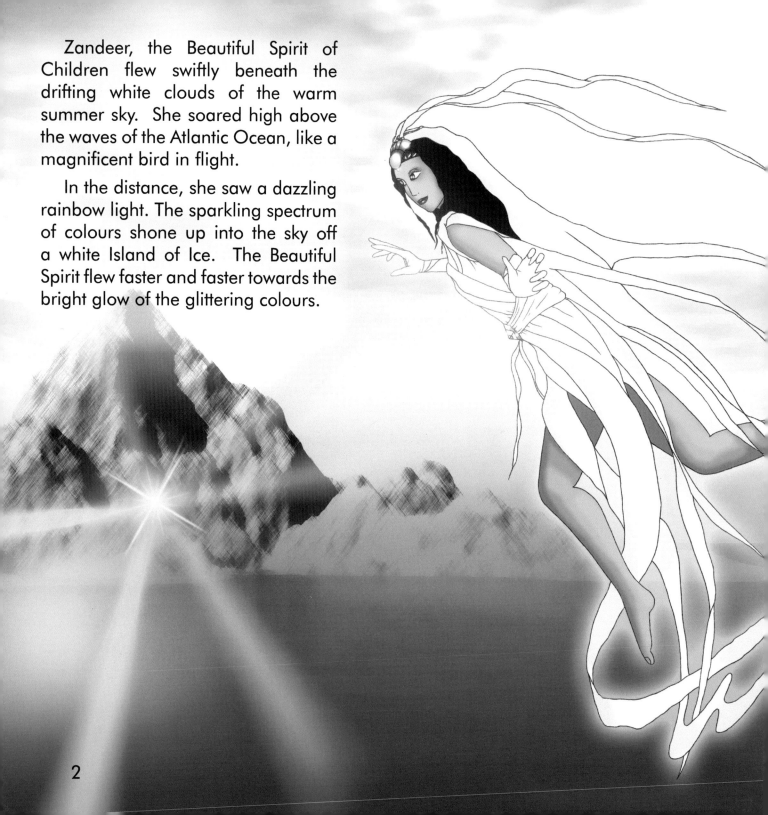

Zandeer, the Beautiful Spirit of Children flew swiftly beneath the drifting white clouds of the warm summer sky. She soared high above the waves of the Atlantic Ocean, like a magnificent bird in flight.

In the distance, she saw a dazzling rainbow light. The sparkling spectrum of colours shone up into the sky off a white Island of Ice. The Beautiful Spirit flew faster and faster towards the bright glow of the glittering colours.

2

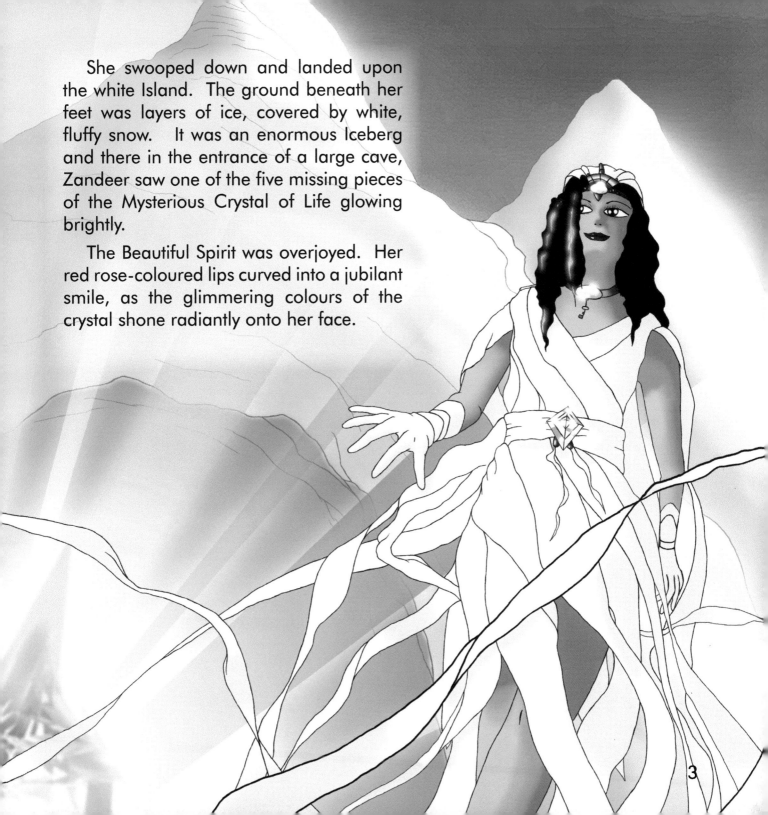

She swooped down and landed upon the white Island. The ground beneath her feet was layers of ice, covered by white, fluffy snow. It was an enormous Iceberg and there in the entrance of a large cave, Zandeer saw one of the five missing pieces of the Mysterious Crystal of Life glowing brightly.

The Beautiful Spirit was overjoyed. Her red rose-coloured lips curved into a jubilant smile, as the glimmering colours of the crystal shone radiantly onto her face.

3

Zandeer walked towards the cave hearing only the sound of her own footsteps crunching in the snow. She gazed around the white, endless, empty land and felt suddenly saddened.

Bewildered, she said to herself: "Hmmmm. This is a strange land. Where are all the humans and animals?" She glanced up towards the clouds. "Oh my," she exclaimed in dismay seeing the empty sky. "There isn't even a single bird in the air."

The Beautiful Spirit went inside the cave and knelt down beside the huge Crystal. She felt so alone. She wished she could leave the deserted Island and return to her home in the heavens to the celestial Kingdom of Heavenina. But that was impossible! First she had to find a human with a pure heart to become the Guardian for the Mysterious Crystal of Life.

"How will I find a Guardian for the Crystal here?" She said sadly to herself. "No human will come to this dreary place." But in the glow of the Crystal's mysterious energies Zandeer could not feel sad for long.

"I know," she exclaimed happily, "I shall use my magical powers to make this land dazzling."

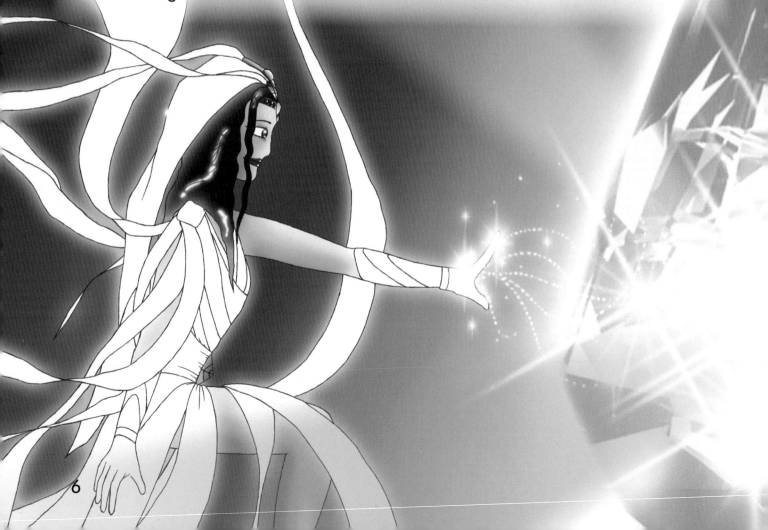

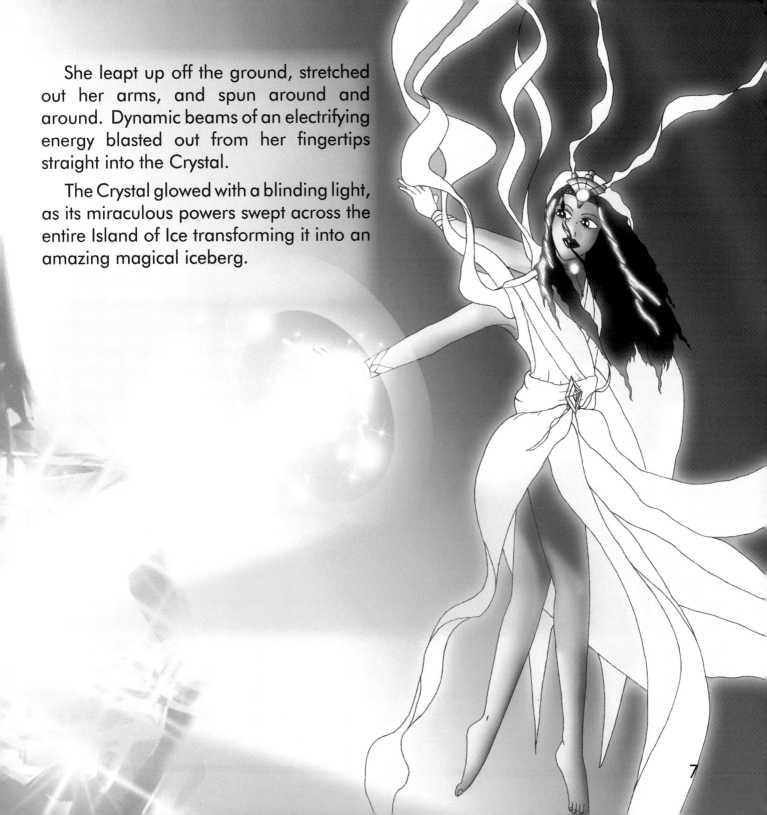

She leapt up off the ground, stretched out her arms, and spun around and around. Dynamic beams of an electrifying energy blasted out from her fingertips straight into the Crystal.

The Crystal glowed with a blinding light, as its miraculous powers swept across the entire Island of Ice transforming it into an amazing magical iceberg.

7

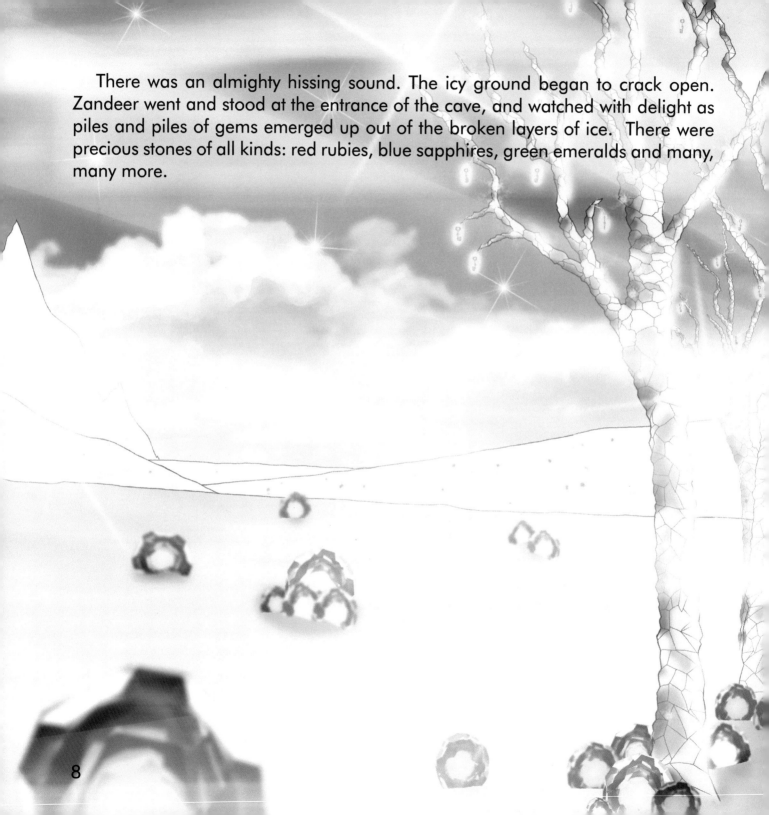

There was an almighty hissing sound. The icy ground began to crack open. Zandeer went and stood at the entrance of the cave, and watched with delight as piles and piles of gems emerged up out of the broken layers of ice. There were precious stones of all kinds: red rubies, blue sapphires, green emeralds and many, many more.

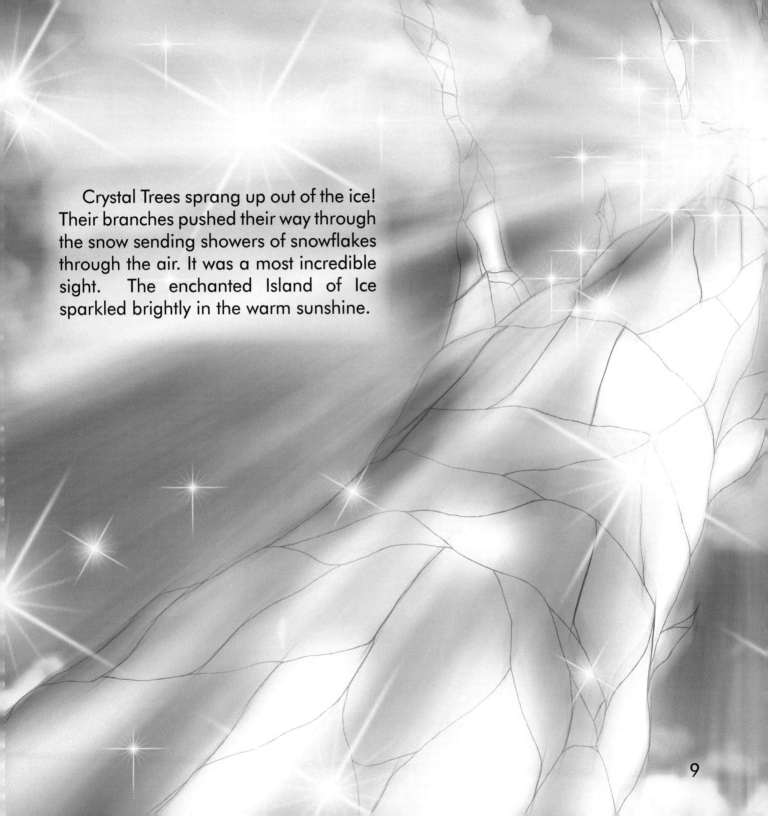

Crystal Trees sprang up out of the ice!
Their branches pushed their way through
the snow sending showers of snowflakes
through the air. It was a most incredible
sight. The enchanted Island of Ice
sparkled brightly in the warm sunshine.

9

Zandeer danced merrily towards the magnificent Crystal Forest. She saw hundreds of tiny crystal keys hanging down from the crystal branches. The branches swayed in the breeze, and the crystal keys tinkled softly together creating a lovely musical harmony. The Beautiful Spirit began singing a delightful song, as she danced through the Crystal Forest towards the edge of the magical iceberg.

"Whispering winds, oh, whispering winds.

Carry my voice in the song that I sing.

The mystery I bring: the magic of love.

The magic of love from my world up above.

I sing a song of treasures glowing.

Love from my heart never stops flowing.

The magic of love is now in the snow.

A mystical land where precious gems glow.

Hold the Magic. Hold the Love.

Whispering winds hear me sing.

Tell the sailors of the magic I bring.

I am a Spirit, a Spirit of Love.

I come from a beautiful world up above.

Whispering, whispering, oh whispering winds ..."

10

The gentle currents of the ocean surrounding the Island of Ice pulled and pushed the waters, creating swells which washed against the icy shores. The rainbow colours of the precious gems skipped across the waves, casting their brilliant glow far out to sea as the winds carried the sweet sound of Zandeer's voice to far-off lands.

The Beautiful Spirit waited and waited. She stood looking out over the vast blue ocean, longing to see a ship sailing towards her enchanted Island of Ice. The days turned into weeks, and the weeks passed to months. But still no ship sailed to the magical iceberg. Time passed and after a year, Zandeer decided to use her magical powers once again.

"I will create a new life for this enchanted Island of Ice, and then, when I leave here, the Guardian of the Crystal will protect them." She said.

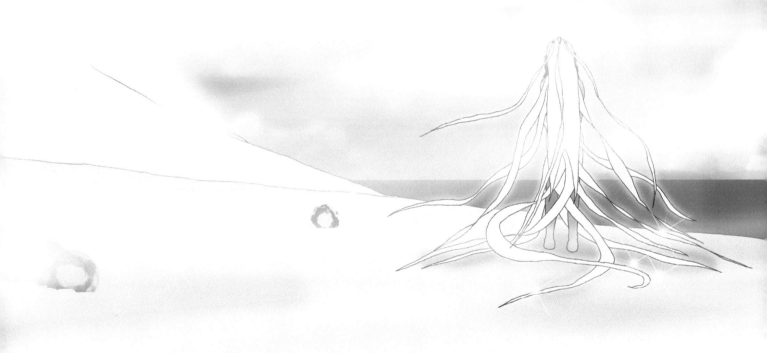

Zandeer went back into the cave and stood behind the Crystal. She closed her eyes and stretched out her arms. Within her thoughts, she summoned up her most heartfelt wishes.

The magic suddenly exploded! An awesome sound crackled throughout the cave as images of children's faces flickered through her thoughts.

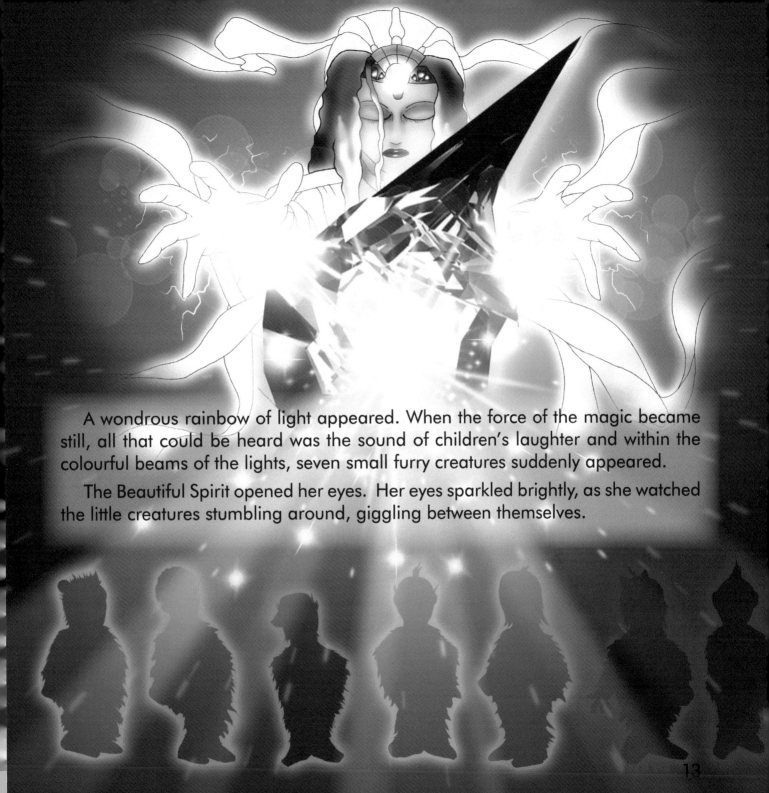

A wondrous rainbow of light appeared. When the force of the magic became still, all that could be heard was the sound of children's laughter and within the colourful beams of the lights, seven small furry creatures suddenly appeared.

The Beautiful Spirit opened her eyes. Her eyes sparkled brightly, as she watched the little creatures stumbling around, giggling between themselves.

13

The furry creatures scampered out of the cave. Zandeer followed closely behind and watched as they played happily in the snow.

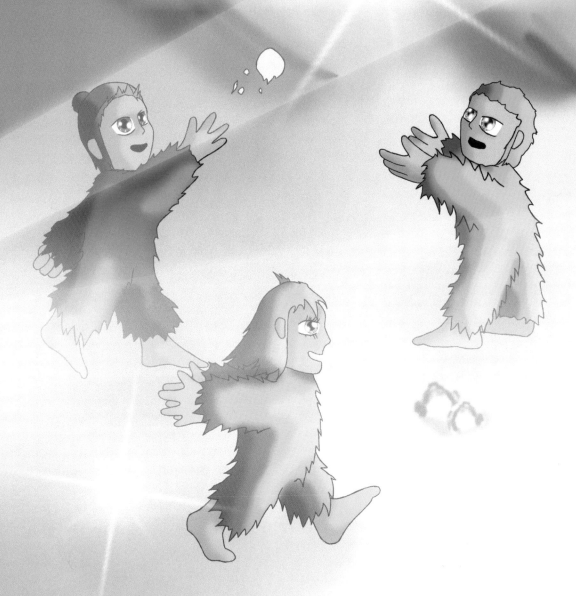

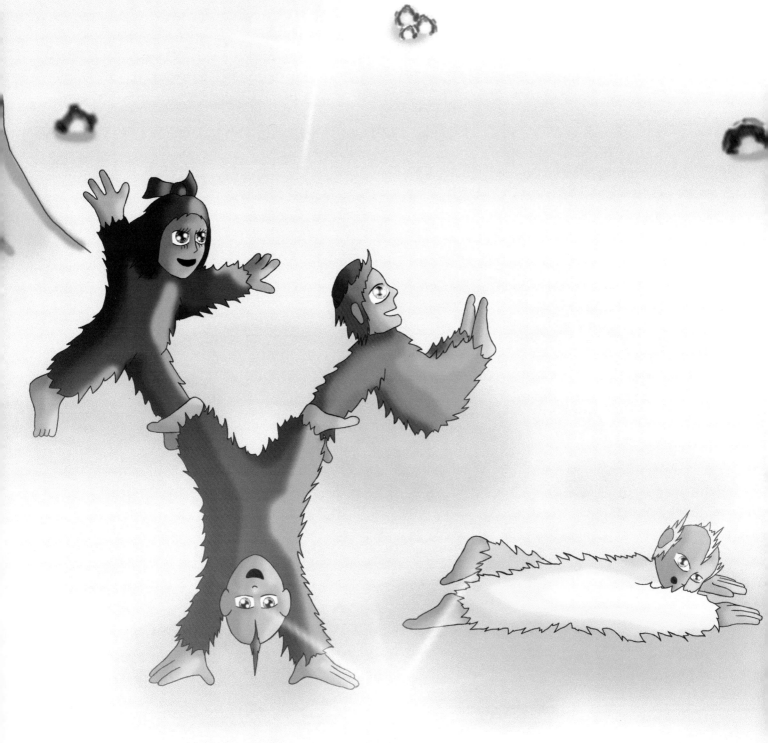

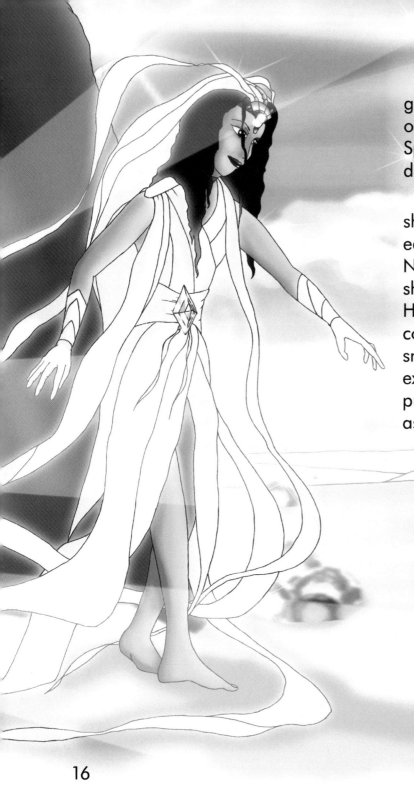

The little creatures stood in a line. They gazed up at Zandeer, their eyes wide open with bewilderment. The Beautiful Spirit noticed each one of them had a different colour of fur.

"You shall be known as the Snowmites," she laughed gleefully. "And I shall give each of you your own special name. Now what can they be?" She mused as she glanced around the magical iceberg. Her gaze fell upon the many different coloured gems glistening brightly in the snow. "Why of course!" she exclaimed excitedly. "You shall be named after the precious gem which is the same colour as your fur."

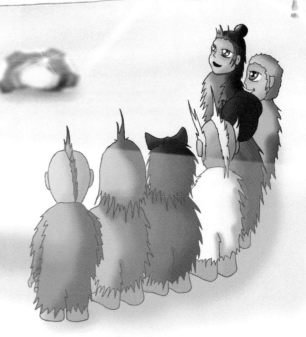

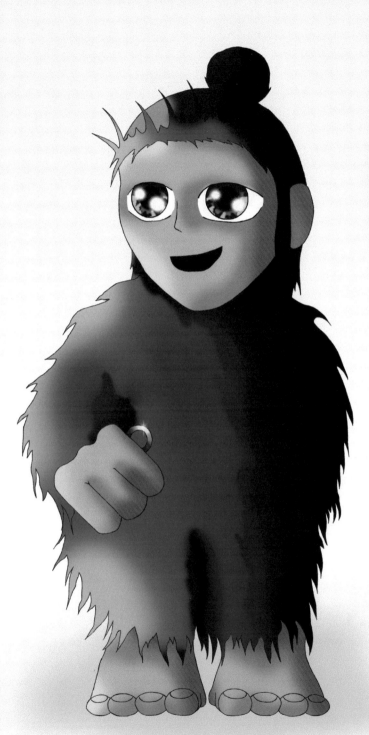

Zandeer smiled down at the first Snowmite standing in the line and beckoned him towards her. "Your fur is the same colour as the gem Aquamarine. So I shall name you Aqua."

She turned to the second Snowmite and said: "Your fur reminds me of the gem Turquoise. Therefore, your name will be Turquo."

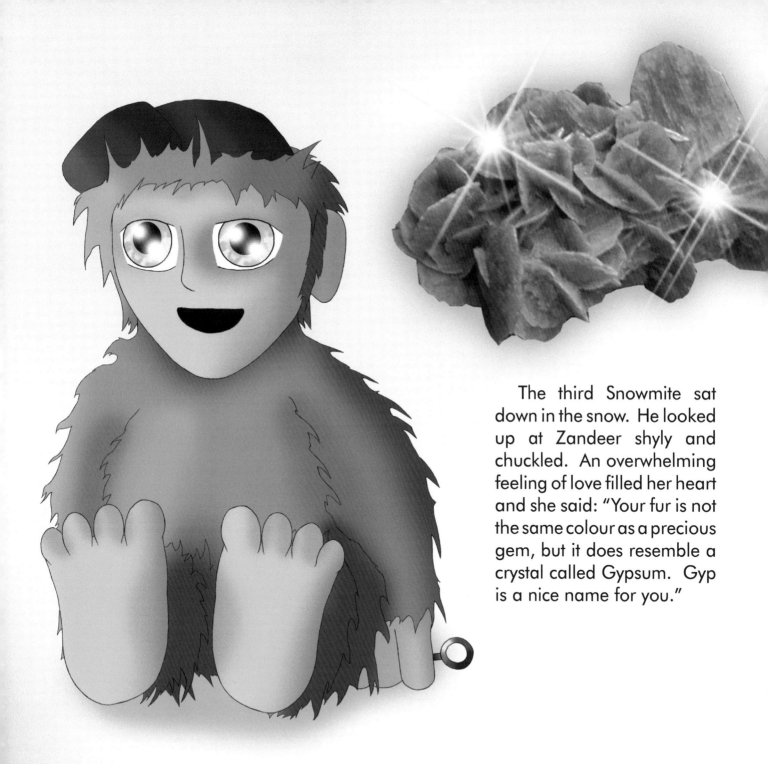

The third Snowmite sat down in the snow. He looked up at Zandeer shyly and chuckled. An overwhelming feeling of love filled her heart and she said: "Your fur is not the same colour as a precious gem, but it does resemble a crystal called Gypsum. Gyp is a nice name for you."

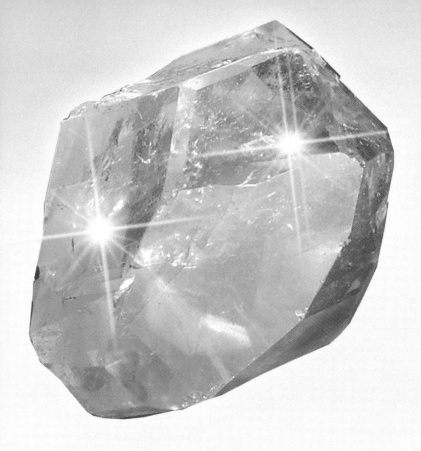

The fourth Snowmite stretched up his arms and yawned loudly, "Yawnnnnn!" Zandeer blinked back her surprise. "Oh! My!" She said in astonishment. "You sound very tired." The little Snowmite yawned again and closed his eyes.

"Well sleepy one, as your fur is the same colour as the precious gem Topaz, I think Topaz should be your name," she told him.

20

"I know what my name can be!" said the fifth Snowmite. She spoke boldly and grinned proudly. Zandeer gazed down at the little Snowmite. "And what do you think it should be then?" she asked.

"That one!" answered the little purple Snowmite pointing to a purple gem. The Beautiful Spirit laughed happily. "Gosh! You are very clever. That is Fluorite. Would you like to be called Fluo?" asked Zandeer. The little Snowmite went silent for a moment. "Fluo, Fluo, hmmm, oh yes! I like that name," she answered beaming a big smile. "It's super duper."

A little green Snowmite with a far away dreamy look in her eyes stepped towards Zandeer.

"Your fur is the same colour as the precious gem Jade," said Zandeer. "So my little princess, you shall be called Jadea."

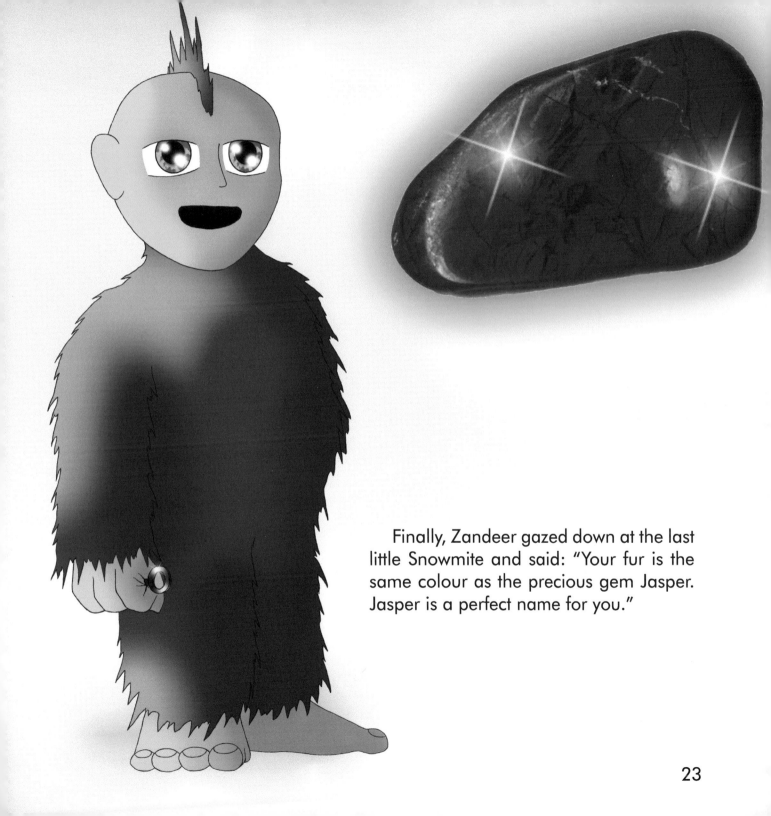

Finally, Zandeer gazed down at the last little Snowmite and said: "Your fur is the same colour as the precious gem Jasper. Jasper is a perfect name for you."

23

Fluo tugged at Zandeer's silky white gown. "Excuse me," she said politely. "What is the precious gem called that you are named after?"

Zandeer took hold of Fluo's hand. "I am not named after a precious gem," she answered in a gentle voice. "Let's all go and sit down in the Crystal Forest. I have a very special story to tell." Zandeer and Fluo walked off towards the Crystal Forest, followed by the other six Snowmites.

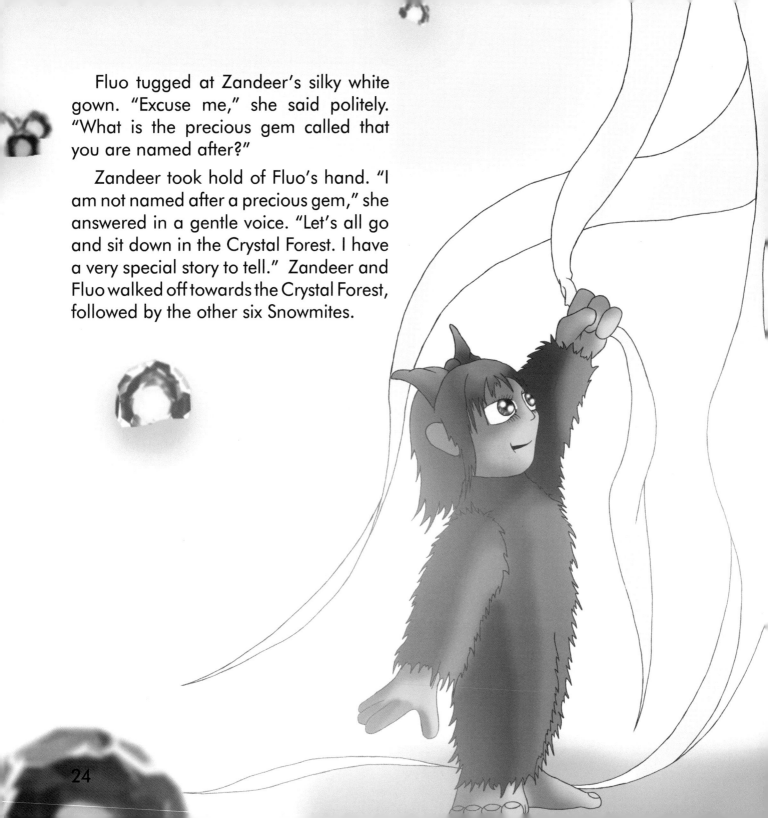

The Beautiful Spirit sat down on a huge diamond rock, and the seven furry Snowmites sat down in front of her. "My name is Zandeer and I am the Beautiful Spirit of Children." She began her story: "I come from a mystical world called Heavenina."

"Oooohhhhh, that sounds lovely," cooed Jadea, smiling dreamily.

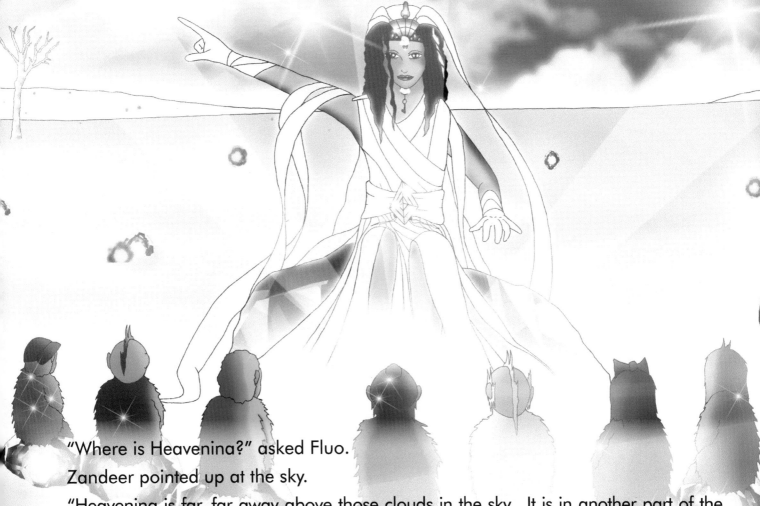

"Where is Heavenina?" asked Fluo.

Zandeer pointed up at the sky.

"Heavenina is far, far away above those clouds in the sky. It is in another part of the universe," she answered. The little Snowmites gazed up at the sky. "Wow!" they exclaimed in sheer astonishment. They looked back at Zandeer, eager for her to continue her story.

"Heavenina is a very mystical world. Every building is made from the rarest of precious gems, the purest gold and the finest silver and magnificent crystals that sparkle brightly.

There are also two moons in our sky, which create a rainbow of the most incredible colours within the clouds. So there is never any darkness in the land of Heavenina. We are called the Spirits of Love and I am one of seven Spirits who are known as The Spirit Council, and we protect our world and guard the Mysterious Crystal of Life."

"The Mysterious Crystal of Life," quizzed Aqua bewildered. "What's that?"

"Do you all remember that big Crystal inside the large cave?" Zandeer asked.

The Snowmites nodded their heads.

"That is the Mysterious Crystal of Life, but it is only a very small piece of it."

"But it's enormous!" piped up Jasper in disbelief, "it's even bigger than you!"

"Yes it is. And there are five other pieces which are just as big. When all the pieces were once together it was one massive Crystal," explained Zandeer.

"Wow!" the Snowmites exclaimed, flabbergasted. They sat very still, listening carefully, mesmerized by the amazing story.

"Who are the other Spirits in the Spirit Council?" asked Turquo, wondering if they were all as nice as Zandeer.

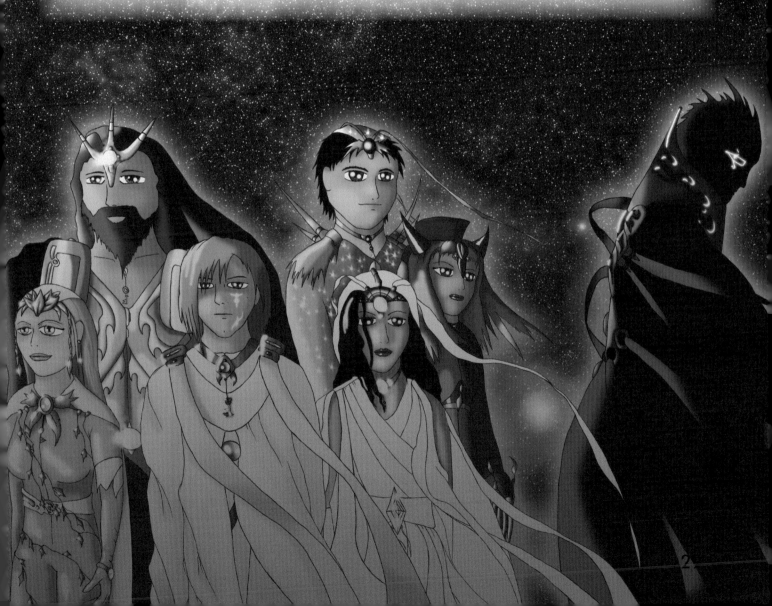

"They are Nymous, the Spirit Lord; Gallius, the Wise Spirit of the Galaxies; Zeprus, the Noble Spirit of Oceans; Zelpha, the Protecting Spirit of Animals; Gadamar, the Gentle Spirit of Nature, and Perilon, the Spirit-Wizard," replied Zandeer.

"But Perilon is no longer one of the Spirit Council, as he did a very bad thing which changed everything."

2

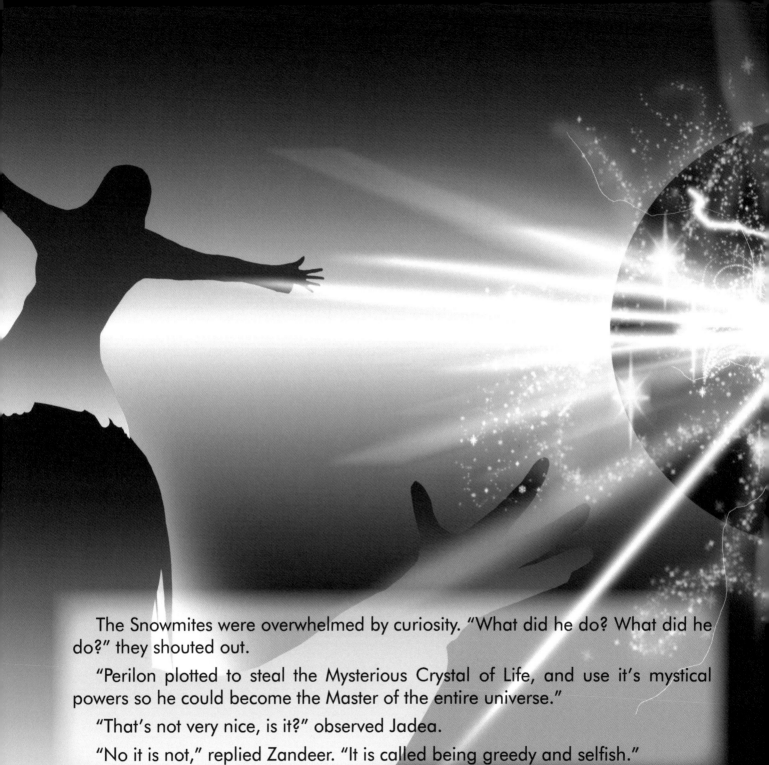

The Snowmites were overwhelmed by curiosity. "What did he do? What did he do?" they shouted out.

"Perilon plotted to steal the Mysterious Crystal of Life, and use it's mystical powers so he could become the Master of the entire universe."

"That's not very nice, is it?" observed Jadea.

"No it is not," replied Zandeer. "It is called being greedy and selfish."

30

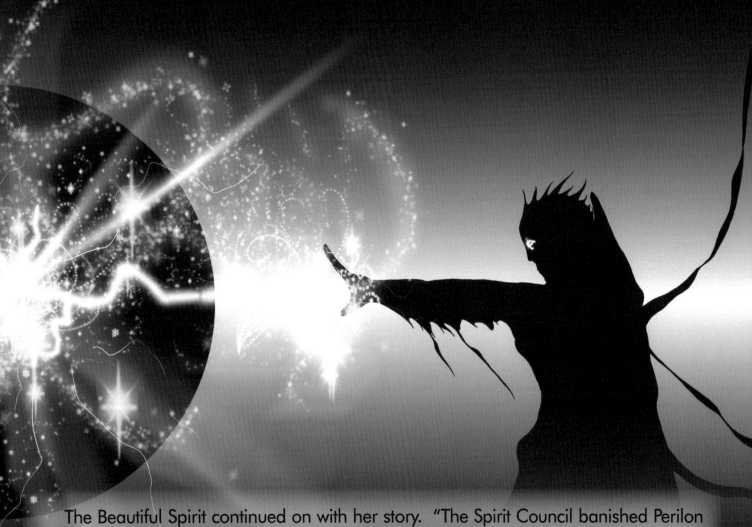

The Beautiful Spirit continued on with her story. "The Spirit Council banished Perilon from Heavenina. Perilon was very angry, and vowed to take revenge upon us all declaring he would take the Mysterious Crystal of Life and the Spirit Council could not stop him."

"I don't like Perilon!" said Gyp frowning glumly. "He sounds horrible."

"What happened next?" Fluo asked.

Zandeer sighed deeply, remembering Perilon's terrible deeds.

She said: "The Spirit Council left Heavenina and journeyed with the Mysterious Crystal of Life to protect it. We all thought Perilon had gone far away but he was following us.

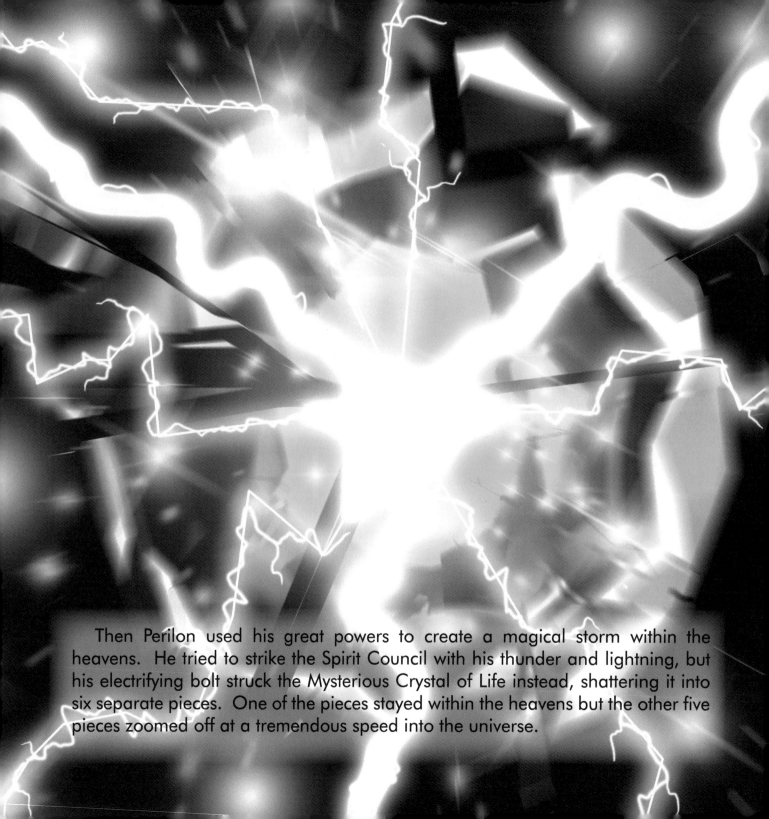

Then Perilon used his great powers to create a magical storm within the heavens. He tried to strike the Spirit Council with his thunder and lightning, but his electrifying bolt struck the Mysterious Crystal of Life instead, shattering it into six separate pieces. One of the pieces stayed within the heavens but the other five pieces zoomed off at a tremendous speed into the universe.

Perilon raged with fury. He flew away chasing after the five speeding pieces of the Mysterious Crystal. Nymous stayed in the heavens to protect the Crystal that was still there, and the rest of the Spirit Council left him to go and search for the five missing Crystals.

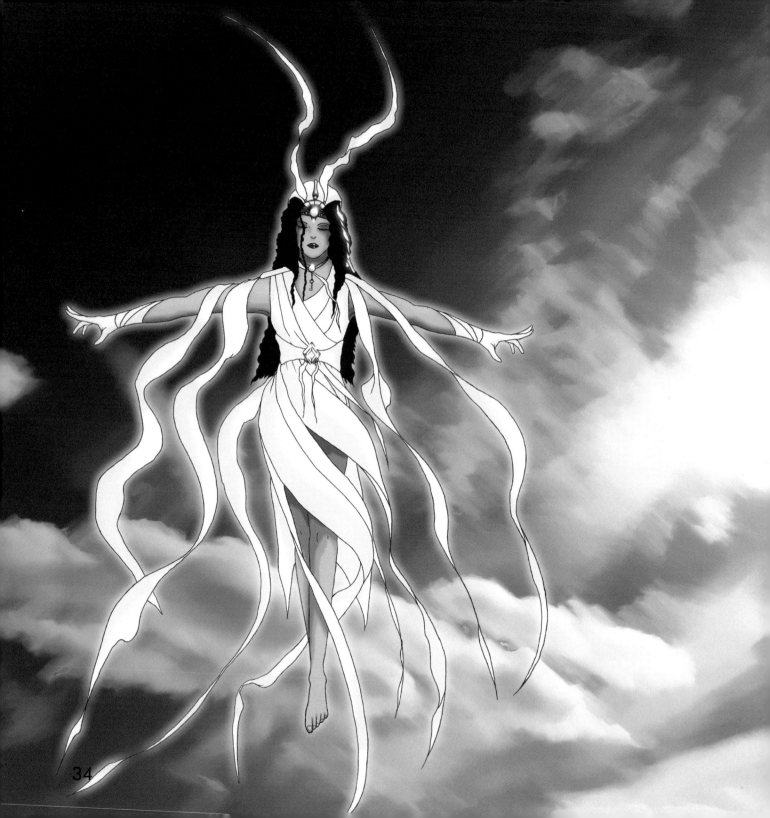

I soared through the skies and flew over the lands of this planet for a very long time. Then finally, I found one of the missing Crystals on this Island of Ice," sighed Zandeer, finishing her story about Perilon.

"Are we going to take the Mysterious Crystal of Life back to the heavens with you Zandeer?" asked Aqua excitedly. Zandeer smiled. The little Snowmites were so adorable.

"No Aqua, we must wait together until a human with a pure heart comes here. He will become the Guardian of the Crystal. He will protect the Crystal from Perilon's evil clutches, and keep you all safe, and then I will go back to Heavenina."

A tear began to roll slowly down Gyp's cheek, as he listened to Zandeer. "Does that mean you are going to leave us ...?" he cried sadly.

Zandeer gently wiped Gyp's tear away from his cheek. "Yes Gyp, one day I must leave here. This world is not my home."

"But I don't want you to go!" wailed Gyp. Suddenly a stream of tears gushed out from his eyes.

36

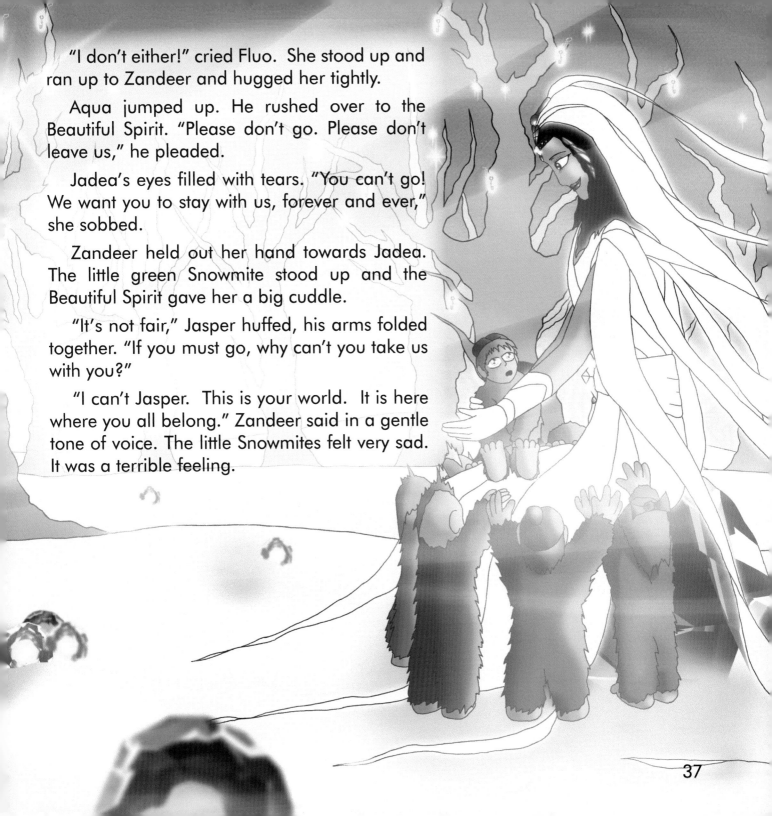

"I don't either!" cried Fluo. She stood up and ran up to Zandeer and hugged her tightly.

Aqua jumped up. He rushed over to the Beautiful Spirit. "Please don't go. Please don't leave us," he pleaded.

Jadea's eyes filled with tears. "You can't go! We want you to stay with us, forever and ever," she sobbed.

Zandeer held out her hand towards Jadea. The little green Snowmite stood up and the Beautiful Spirit gave her a big cuddle.

"It's not fair," Jasper huffed, his arms folded together. "If you must go, why can't you take us with you?"

"I can't Jasper. This is your world. It is here where you all belong." Zandeer said in a gentle tone of voice. The little Snowmites felt very sad. It was a terrible feeling.

"Don't be sad," said Zandeer reassuring them. "There is something very special you all have to do." She pointed up at the crystal keys hanging down from the crystal branches.

"Those crystal keys belong to the hearts of real children who also live in this world. Whenever you see them glowing, it means that the child to whose heart the glowing crystal key belongs is feeling very sad and lonely and needs you. Sometimes children feel sad because they are being bullied by others, which is not nice. They may be unhappy because they are hungry and have no home, or no-one to look after them. There are lots of reasons why children may often be sad. And your friendship will help them to feel happy again."

The Snowmites listened silently. Finally, Fluo spoke out: "Zandeer are you saying there are others like us living here?"

Zandeer smiled. "Yes Fluo, I am. But children don't have fur to keep them warm because they don't actually live on your Island of Ice. This planet is called earth. It has many different countries, and very soon, you will be able to go and visit them."

Aqua was rather befuddled. Scratching his head, he asked: "But when we know a real child needs us, how will we be able to visit them if they don't live on our Island of Ice?"

"Why through 'Magic Dreams' of course!" Zandeer laughed cheerfully. She knelt down and put her arms around the Snowmites, giving them all a gigantic hug.

"Magic Dreams! Magic Dreams! Wow! Are, are, you saying that we are magic?" Aqua stuttered.

The Beautiful Spirit nodded her head. "You certainly are my little ones," she beamed. "In Magic Dreams you will all be able to visit the real children of this world whilst they are sleeping."

"Wow! Brilliant," the Snowmites shouted out in excitement.

The Snowmites smiled. They felt much better now, knowing they would soon have lots and lots of new friends.

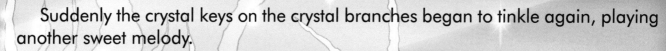

Suddenly the crystal keys on the crystal branches began to tinkle again, playing another sweet melody.

"Aaa-ha," exclaimed Zandeer. "It is time."

"Time for what?" asked Turquo, baffled.

"Why bed-time of course!" Zandeer chuckled. The Beautiful Spirit stood up. She held out her arms towards the Snowmites. "Let us all be happy! Sing, sing, and sing, and dance, dance and dance."

Zandeer began singing another wonderful song. The little Snowmites cheered loudly, and clapped their hands. Then they all started to sing and dance together.

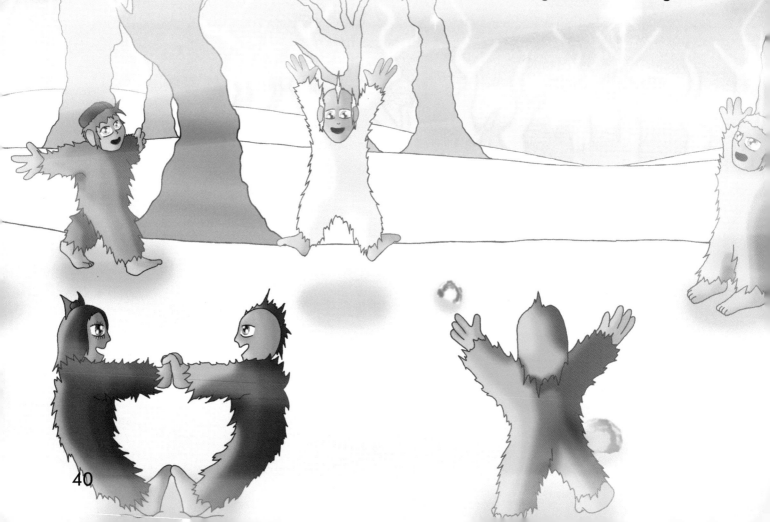

40

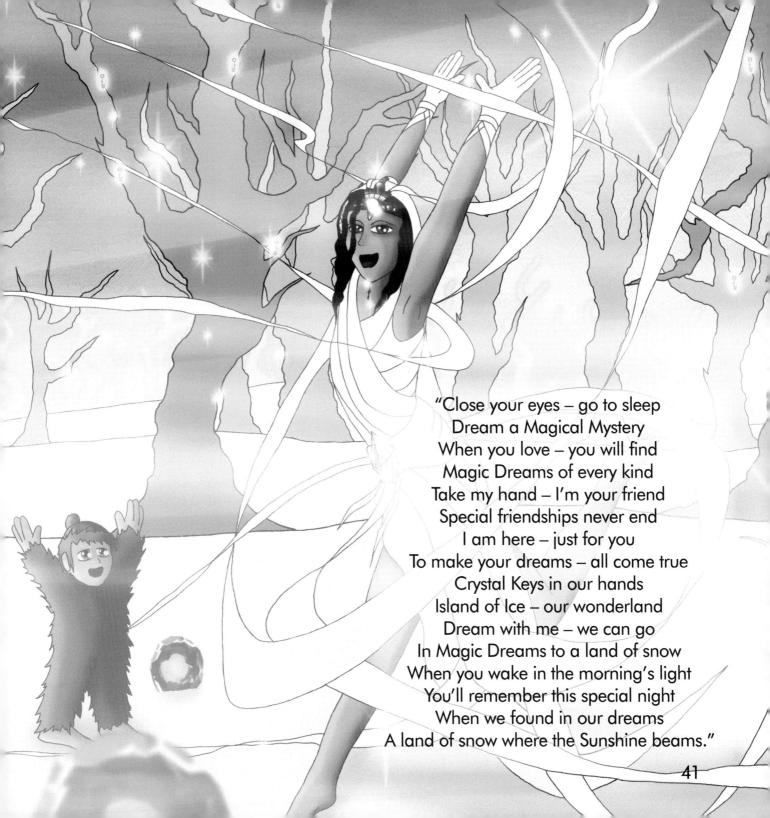

"Close your eyes – go to sleep
Dream a Magical Mystery
When you love – you will find
Magic Dreams of every kind
Take my hand – I'm your friend
Special friendships never end
I am here – just for you
To make your dreams – all come true
Crystal Keys in our hands
Island of Ice – our wonderland
Dream with me – we can go
In Magic Dreams to a land of snow
When you wake in the morning's light
You'll remember this special night
When we found in our dreams
A land of snow where the Sunshine beams."

41

The little Snowmites soon began to feel very, very, tired. One by one, they stopped dancing and yawned wearily. Zandeer led them back into the large cave and watched lovingly, as they snuggled up into a little snow cradle of their own.

And she was not at all surprised when she saw Topaz was the first Snowmite to curl up and fall fast asleep!

"Zzzzzzzzzzzzzzzzzzzzzzzzzzzzzzzzzzzzz," snoozed Topaz.

"Zzzzzzzzzzzzzzzzzzzzzzzzzzzzzzzzzzzzz," snoozed Turquo.

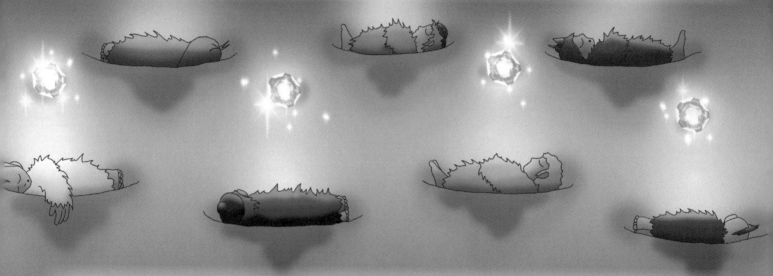

"Zzzzzzzzzzzzzzzzzzzzzzzzzzzzzzzzzzzzzzz," snoozed Aqua.

"Zzzzzzzzzzzzzzzzzzzzzzzzzzzzzzzzzzzzz," snoozed Jadea.

"Zzzzzzzzzzzzzzzzzzzzzzzzzzzzzzzzzzzzz," snoozed Fluo.

"Zzzzzzzzzzzzzzzzzzzzzzzzzzzzzzzzzzzzz," snoozed Jasper.

And finally last of all!

"Zzzzzzzzzzzzzzzzzzzzzzzzzzzzzzzzzzzzzz," snoozed Gyp.

"Magic Dreams my sweet little ones," whispered Zandeer, giving each one of the Snowmites a gentle kiss on the forehead.

The Beautiful Spirit turned round smiling happily. She blew a kiss into the air. Then she whispered, ever so tenderly, for every real child in the world to hear.

"And Magic Dreams to you all."

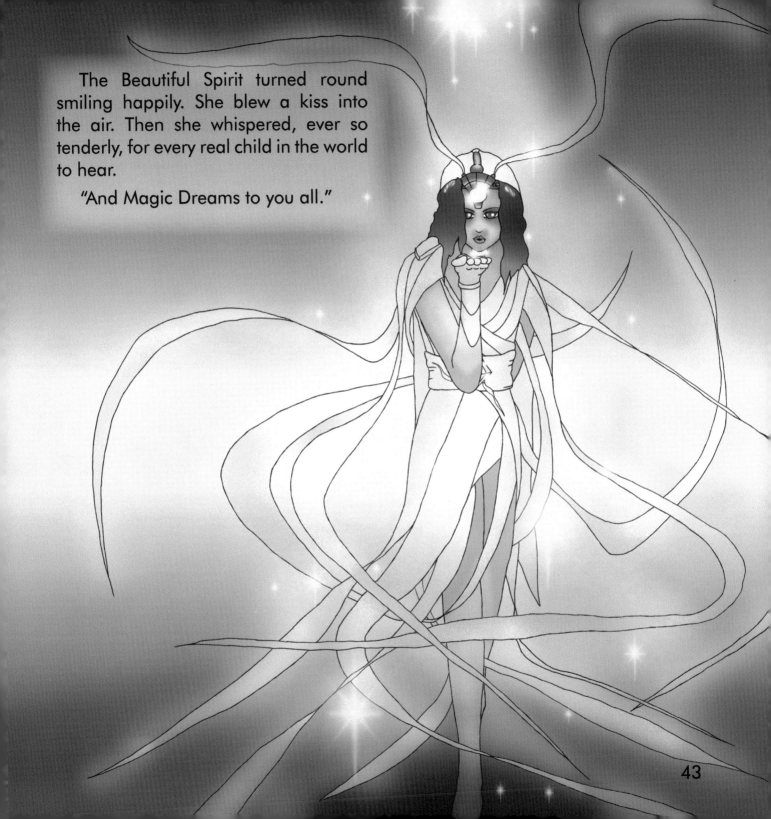

Aqua

Turquo

Hello from the Snowmites

Topaz

Gyp

*We are the Snowmites,
having lots of fun.*

*Caring and sharing
for each and everyone.*

*We are the Snowmites,
a happy bunch are we.*

*Never feeling sad or lonely
that should never be.*

Jadea

Fluo

Jasper

44

THE SNOWMITE FRIENDSHIP CLUB

Would you like to write to your very own special Snowmite Friend?
And receive a letter back from them?

Then please ask a Parent or Guardian to help you find out how you can join
The Snowmite Friendship Club.

Information for Parents and Guardians Only: Please Log onto

www.merlincorp.org

Printed in the United States
1438LVUK00002B